Foreword

This book is written to explain the technique of writing with the pointed pen in the Roundhand style. This is the American version of the so-called Copperplate style, popular in England in the seventeenth and eighteenth centuries. Roundhand (or Copperplate), sometimes called Spencerian, or Engraver's Script, or Formal Script, is the object of much interest among calligraphers, who, unfortunately, are often unable to find good teachers or books, although broadpen lettering, especially italic, is well represented in both categories.

Roundhand Script is a particular kind of ornamental penmanship that appeals to many people (like us). It is more difficult than broadpen, and therefore more challenging, but

despite its being a cursive script, it is less personal than most good broadpen lettering. It is more mechanical, more demanding of precise technique and less forgiving of imperfections.

But, it's so beautiful when it's well done!

And of course that's why we try to master it. That's our reason for spending hundreds of hours studying and practicing calligraphy. The deep-down reason, no doubt, is ego, but without ego, very little beauty in any field would be produced.

It is sincerely hoped that this book will be a help to those who want to learn this script, and that it will help them to avoid the bad habits that plague the self-taught.

Left-handers can write the script with an ordinary straight pen, hand under the line, but right-handers, because of the extreme slant of the letters, are almost compelled to use an elbow pen, available at most art supply stores. Good luck.

Let's start at the beginning.

You will need pen, ink and paper. For the present, that's all. The pen is a pointed, flexible nib in an offset holder — an elbow pen. Buy a half-dozen different kinds of nibs. The ink is a free-flowing, non-waterproof black. Fountain pen ink will do. India ink is not suitable. The paper is a tablet of 13½ lb., 100% rag, white bond.

In Roundhand Script, there are two major concerns: Form and Freedom. Form, of course, has to do with the shapes of the letters, the proportions, the weight of the swelled strokes called shades, the consistency of the slant and such things.

Freedom is harder to define. It is an intangible, yet a definite part of good Roundhand, and of all good calligraphy, for that matter. It is seen in the grace and "swing" of good lettering of all kinds.

Roundhand is definitely not handwriting. It is lettering, pure and simple. The forms of the letters are set, allowing very little variation. The letters are composed of strokes that must be precise and mechanical and that produce precise and mechanical letters and words. When Roundhand is learned in the usual way, by forcing it to conform to ruled guide lines, freedom suffers and stiffness results.

It is better to work on the freedom first, learning the strokes and drawing the letters without those constraints that only create tension.

Later on, you will be able to fit the freely-formed letters into tighter forms and into guide lines with a much happier result.

Don't forget that you are doing lettering. You are not writing the letter a, for instance. You are drawing the curved stroke, attaching the straight stroke and adding a ligature. Together, they form the letter a, but your concentration must be on the individual strokes.

Before trying to use your elbow pen, check the align-

ment. The nib must point in exactly the direction of the slant of the letters, 54 or 55 degrees off the horizontal. If it does not, alter it to make it conform. As a last resort, make your own.

When you do this style of lettering, you will probably have to turn your hand slightly to the right for the proper feel and control.

You can determine the proper slant by using this diagram: 4 up, 3 across.

54 degrees

Lower Case

Almost all of these letters can be made with combinations of only two strokes — plus their minor variations. The straight stroke and the curved stroke appear time after time after time.

The straight stroke has many different beginnings and endings. The curved strokes are identical in all of the letters.

The Straight Stroke

It is hard to think of a straight line as having more than one part, but there are three: the flat top, the line itself and the square cutoff at the bottom.

Good Roundhand Script is sharp and crisp. Contributing strongly to this effect is this straight stroke, which must be unwavering and must have four sharp corners. It should be a strong, direct stroke; otherwise, the crispness is lost. Practice it carefully.

This is the way it's done. (1) Place the nib on the paper and apply pressure, forcing the left blade to the left, thereby forming the flat top. (2) Without lifting the pen, draw the heavy downstroke and stop the pen (without lifting it) and (3) allow the right blade to snap to the left and form the cutoff.

This stroke requires serious practice, even though the pen manipulation is easier than you might think.

Variations of the Straight Stroke

Begin the stroke with the same pen manipulation as in the straight stroke. As you near the bottom, release the pressure from the left blade and allow it to join the right. Lift the pen, then draw the hairline upward.

The hairline is drawn upward and the pen lifted. Then draw the heavy stroke, starting with only a point, but quickly adding pressure, forcing the right blade to the right, finishing with the square cutoff.

This is a combination of the other two. Lift the pen at the top and bottom. The top turn should be the exact reverse of the bottom turn. The reason for the pen lift is that it allows greater control of the next stroke.

There are several ways to draw this stroke. Choose the most comfortable. In this case, the hairline is a continuous upstroke with only a slight hesitation at the waistline of the letter. In all cases, let the counter (the enclosed white space) form a teardrop.

It is advisable to add a little extra weight to the right-hand side of the teardrop to give it strength.

Draw this stroke, and all strokes, carefully and don't think of it as handwriting.

When you draw the heavy downstroke, concentrate on the right side of the nib. Let the left half of the nib form the shade automatically while you keep your eyes on the right.

These two strokes complete the group of variations of the straight stroke in lower case. They demand precise control of the increase and decrease of pressure in order to form a graceful and pleasing letter.

Practice these straight stroke letters in about the size shown below. Don't worry about uniformity. Strive for a free and relaxed hand movement.

ffff hhhh iiii jjjj
llll mm m m m nnnn
ttttt uuuuu yyyy

The Curved Stroke

This stroke, rather difficult to do well, is based on an ellipse. Not the usual orthographic ellipse, in which the two axes are at right angles, but an isometric ellipse, with one axis parallel to the slant of the letters and the other parallel to the horizontal line. It requires some concentration at first.

The Isometric Ellipse

The center of the letter o should be an isometric ellipse. The letter is drawn in two strokes. The left is a downstroke, heavily shaded. The right is usually an upstroke, but can be made downward with a very light shade on the upper part. If an upstroke, add a little weight to it.

There are eight lower case letters that use the curved stroke in their construction. The stroke is identical in every case. Even some of the letters are very similar. Compare the a, d, g and q. The letter r in this group is known as the French r; the other is the English version. Practice both. In your writing, use whichever you like.

Watch the right-hand side of the nib. This will help you to maintain a well-shaped center oval.

acdegoqr

Practice in this size: a c d e g

You will notice that there are a few strokes in the alphabet below that have not been introduced yet. They are not difficult and will not present problems. No descriptions or explanations are necessary. Careful practice will do it.

Concentrate at first on the shapes of the letters; later on the weight and uniform slant.

Here's what all this is leading up to.

abcdefghijklm

nopqrstuvwxy

z

Now you can start forming words, using lower case letters. Don't use any pencilled guide lines. Try for well-shaped, flowing letters in any size that's comfortable. Relax your hand. Take it slow and easy. Concentrate more on individual strokes than on letters.

Let your practice paper look like this:

the quick brown fox jumps over the lazy dog. elbow pen

penmanship roundhand

resolutions and testimonials

little things perfection make,
— but —
perfection is no little thing.

Capitals

Capital letters are made with arm motion, the muscle of the forearm resting on the desk and acting as a pivot. The fingers do not form the letters, but do exert pressure to form the shades. Although these letters are composed of many kinds of strokes, one, the compound curve, predominates. It is a part of a surprising number of letters.

B E F G H I J K

L P R S T V W Y

and *I*

The stroke appears also in *N*, but unnaturally, because of the direction.

The forms of the lower case letters are set and allow very little variation, but capitals are not that "tight". There are many forms of each letter and opportunity also to create your own by swinging a curved line up, down or out, for instance, farther than in the model. The letters below are more or less standard. Learn them well before you start improvising.

Lift the pen after each heavy downstroke. Then, with a relaxed hand, draw the hairline.

A B C D E F G

H I J K L M N

O P Q R S T U

V W X Y Z

Alternate Forms of Capitals

There are many different forms of capital letters. On the following pages are a few of them. They are composed almost entirely of curved lines, and in order for us to draw them with freedom and a graceful flow, we must use hand movement.

Don't clench the pen. Relax the hand and hold the pen just firmly enough to control it.

Capitals are made with hand movement. Be sure you slide your hand on the paper.

It is very important that your forearm rest flat on the desk top. The rotary motion that these letters depend on originates there.

The hairline of the A can be made as an upstroke or a downstroke. In the first example, the loop must be carefully drawn and the shade added later. The loop itself may be made in two strokes, each starting in the center.

The loop that begins the C can be made left to right or, starting near the top, from right to left.

A A A
A A A

B B B
B B B

C C C
C C C

Before you attempt these capitals with a pen, draw them very carefully with a pencil in order to know exactly where each stroke goes.

The first example of capital D is, without a doubt, the most difficult letter in the Round hand alphabet. The long hairline, curving upward and to the left, demands exact control. This form is also the most appropriate for formal writing and, for this reason, must be mastered. With good control, it can be made non-stop, but it will be found easier to lift the pen after the compound curve and start the hairline with a relaxed hand.

E will present no problems. Turn the paper for F's top.

17

Capital letters should be written with enough speed to produce smooth, flowing and gracefully curving lines.

The dot at the end of the compound curve (in the first G) should be the same weight as the shades. The beginning loop should be part of a slanting ellipse, and after the downstroke (shade), the pen forms an upward hairline that is roughly parallel to the oval.

H often has a long hairline that, in a casual scan, almost disappears. Some writers call attention to the hairline, as in example 2.

I and J are easily made too narrow. Swing them wide to allow them to dominate their words.

18

Be very certain you understand the proper construction of a letter; then practice it correctly. Don't practice mistakes.

The hairline of J's lower loop can be an upstroke or a downstroke, but in either case, the pen is usually lifted before crossing the wet shade, and the line resumed on the other side, leaving only a tiny, imperceptible break. Incidentally, a heavy line NEVER crosses a heavy line.

K presents the same problem as J: crossing a wet shade. Sometimes you can get away with it, sometimes you pick up a fiber and smear a letter. Be careful.

Rome wasn't built in a day. Nor are penmen. Patience is a noble virtue.

Position yourself and the paper so that downstrokes are pulled toward the center of the body. The pen can be lifted after any stroke, whenever it will help the writing.

Practice these capitals in about the same size. Strive for freedom of movement, going slowly and carefully at first, a little faster later for smooth lines. Try to keep the slant consistent.

Don't use pencilled guide lines. They will come later.

20

A how-to book is better than no teacher at all.

One of the many difficulties in pointed pen lettering is the so-called push stroke, moving from right to left, as in the first example of P, at the end of the compound curve. We have three options: (1) we can make the stem and bottom curve in a continuous but difficult stroke, then add the dot, or (2) we can lift the pen after the shade and then make the push stroke and add the dot, or (3) we can lift the pen after the shade and make the dot and the connecting stroke from left to right.

Call them anything but majuscules.

Capital letters are often referred to as majuscules and the small letters as minuscules. What ugly words! Even pronounced correctly, and they seldom are, they are still ugly.

The terms capital letters and small letters seem to lack professionalism, and upper case and lower case give a picture of a type-setter at work, so we are left without a really suitable set of names for the letters we work with. Nevertheless, calligraphy has managed to flourish (pun intended) without suitably descriptive names.

"The best laid schemes o' mice and men
Gang aft a-gley."

There are three trouble areas that can doom your best efforts. They are, of course, pen, ink and paper. The pen should be firm enough to be easily controlled, yet flexible enough to give satisfactory shades and fine hairlines.

The ink must be opaque and yet free-flowing, and non-waterproof.

The paper must permit heavy shades without bleeding, and fine lines, too.

More about these later.

There are alternate forms in the lower case, too, as you know, but far fewer. In formal script, deviations are not common, but in casual or personal script, the sky's the limit. You will run across variations from time to time in advertising lettering. Some are interesting; many are not. Some should never have been printed. A few of the best are these:

b d f ff k o p p q r s x x y y z z

The above variations will sometimes be found in good Roundhand Script. Those below are more casual in style and might be found in examples of informal writing in which freedom played a large part.

a b c d d e f ff g h k o p q t tt

and v, w

These variations will relieve the monotony of practicing Roundhand, but emphasis should be on the practicing of the standard forms. Later on, as skill increases, you may want to practice these alternate letters and perhaps incorporate them into your own personal style.

rope trifle except quartz

fad hood book speed wax box

This is a final form of d, almost never used at the beginning or in the middle of a word.

This form of x is outdated.

There are plenty of opportunities to create your own variations, using imagination and a little dash.

25

One of the fundamental rules or principles of script lettering is that all of the ligatures should be drawn upward at exactly the same angle. Generally, we should observe the rule, but there are times when we have to think twice. The problem lies mainly with the letters c, e, s and x. If the ligatures from c, e and x are identical to others, those letters are squeezed into very narrow shapes. If the ligatures leading into s and x are at the normal angle, we have the same problem. Consider the letter c. If we draw the curved downstroke and then bring the ligature up as normally we would, there is very little room for the kern, or dot, and we have a constricted letter like this: c. If we make a more pleasing letter, (c), by allowing ample space for the kern, the ligature must be swung out farther and the rhythm suffers.

Likewise with the letter e. These letters, c and e, can be considered as single-stroke letters, such as i and t, but they are not quite satisfying, even though they don't interrupt the rhythm.

The letter s presents a similar problem, with the

crowding on the other side of the letter. If the ligature from the preceding letter is at the normal angle, we must hold the downstroke of s away from the ligature in order to avoid crowding (*s*), producing a rather boxy-looking letter, similar to an upside down c, and with the same c problem. If we want a more graceful letter (*s*), we have to change the angle of the lead-in ligature.

The letter x has the problem on both sides.

How you handle these letters is up to you. It's a matter of your personal style.

Another rule or principle of script lettering is that the heavy downstrokes should be drawn, when possible, at regular intervals. Of course, not all downstrokes fall in precise order, nor would we want them to. Consider the monotony of picket-fence Blackletter. The rule is better explained graphically, like this:

naturally

Everything goes well until we come to the letter r, where, because the ligature from letter u joins r at the top, equal spacing of downstrokes is not possible, and we have to rely on our own judgment.

Our own judgment, in this case, is a very good thing to rely on. The eye is a much better measurer of such things than a ruler.

Try to maintain an even color throughout the word... and the line... and the page.

Alphabet Sentences

The quick brown fox jumps over the lazy dog.

Pack my box with five dozen liquor jugs.

A quick movement of the enemy will jeopardize six gunboats.

Numerals

1 2 3 4 5 6 7 8 9 0

The above forms of the numerals are common. In practice, each writer has his or her own little idiosyncrasies, but the above may be considered standard. Note that six, nine and zero are fat on both sides, being made with two downstrokes. The short horizontal strokes of two and seven have curlicues to give them weight. Normally, they would be hairlines and would almost disappear. But, oddly, the same stroke on the five is never treated in this way; it is either a hairline or (usually) a double line filled in.

The top curves of two and three are sometimes drawn like this: 2, 3, and sometimes like this: 2, 3. Seven is usually brought below the writing line.

Eight is either 8 or 8, the latter a little the easier, sometimes 8, easier yet. Don't make numerals as tall as the capitals; the same height as t and d is usual.

There is a potential problem of confusion between one and seven. If the lead-in stroke of one is carelessly done, the one could possibly be read as seven. For this reason and the previously noted reason of weight, the top of seven is given a curve to differentiate it from the one, and in addition is sometimes given a horizontal line through the stem: 7.

You will occasionally see numerals that vary in height, as do the numerals that are used with Roman lower case. Here they are:

1234567890

Now that you are familiar with the shapes of all of the letters, you can begin to experiment for the fun of it. Ascenders and descenders can be extended into curlicues, capitals can be embellished and flourishes can be used to fill empty spaces. Invent and have fun!

Aloha *NEW!* *Special*

April Showers

Thanksgiving

You Are Cordially Invited

Christmas

Now is the time

Every man for himself! *Roundhand*

January *The Joy of Writing*

When we think of the pointed pen, we think usually of Roundhand, but the range of styles that are possible with this pen is almost unlimited. In addition to many styles of script, formal and casual, there are endless styles of roman and roman italic that you can investigate. Here are a few suggestions:

ABCDE abcdefgh

ABCDEF abcdefghijkl

This is an Example of the Runninghand, popular in eighteenth Century England.

ABCDEFG abcdefghijkl

ABCDEF abcdefghijkl

Accent just the top.

Or just the bottom.

The Light Touch **Bold 'n Black**

Guide Lines

Formal Script demands uniformity, and to attain uniformity we use pencilled horizontal guide lines and slant lines, erasing them after the lettering is dry. In order to draw uniform guide lines, you will need a drawing board and T square. Also (not absolutely necessary, but great time and energy savers) a lettering guide and an adjustable triangle.

Using the lettering guide and T square, draw horizontal lines at least a quarter-inch apart over your paper. This is a comfortable size to start with. Later on, we'll work with smaller letters.

Then, using the adjustable triangle, draw lines at a 54 or 55-degree angle over the entire paper. In the beginning, the more slant lines, the better.

We use six of these horizontal lines for each line of lettering. Our alphabet fits into the lines in this way: capitals are usually three spaces high, letters with ascenders the same. Lower case one space; t and d are usually a little less than two spaces. The stem of p is the same height. Descenders of p and f are usually one space down. These are not hard and fast rules. You will find variations. For instance, caps are often two-and-a-half spaces. But they will do for now.

ABCDEF

abcdefghij 1234

Don't allow gaps between shades and hairlines as we did in the beginning. There is too much insincerity in Roundhand as it is.

Practical Advice

If the nib looks like this ⟶, possibly it is being squeezed out of shape by the penholder. If so, loosen the holder by prying with a tiny screwdriver.

New nibs usually have a coating of oil which repels ink. The oil can be removed by holding the nib in the flame of a match for a second or two.

The nib will occasionally pick up a paper fiber and ruin a letter. Sometimes the smear can be erased, sometimes not. If you happen to see the fiber before damage is done, stop right there and remove it.

Grace and "swing" can be improved by holding the pen far from the nib; control by holding near the nib.

Control can be further improved by using as short a nib as possible, by inserting it farther into the holder.

It appears that the straight strokes are ruler-

straight. Actually, in the finest examples of Roundhand, there's not an absolutely straight stroke to be found!

Don't try to "write letters". Instead, draw strokes. Try to draw strokes that are geometrically correct. For instance, top turns and bottom turns should be identical.

Write on a tablet of bond paper. Your writing will be sharper if there are several sheets of paper under the writing paper.

Ink can be made more dense by leaving the cap off the bottle for a few days.

Watch the shapes of the spaces.

Fingers are oily. Ink will crawl on oily paper. Keep a sheet of scrap paper under your writing hand.

Clean your tools often. Clean the mouth of the ink bottle, too. Ink dries there and tiny particles drop into the ink and then during writing will be transferred to the paper. When you erase the guide lines, these particles can smear and ruin the work.

A favorite ink of many calligraphers is Higgins Eternal. Another excellent one is Rexel Penstyle Lettering Ink.

There is a large selection of nibs to choose from. Try Gillott 303, 404 and 170; also Hunt 22, 99, 100, 101.

A good paper is Seth Cole Graphic, 100% rag layout and marker bond.

An Irish Blessing

May the road rise up to meet you. May the wind be always at your back. May the sun shine warm upon your face, the rains fall soft upon your fields, and until we meet again, may God hold you in the palm of His hand.

Make your own pens.

Almost everyone has one of these pens.

Remove the cork finger grip and the metal ferrule from the pen staff.

From an ordinary wooden yardstick, cut a piece shaped like this:

Trace this for use as a template, if you like.

Assemble the three pieces, using epoxy cement.

Before the cement hardens, adjust the pen to the proper angle. Later, add more cement to strengthen the assembly.

When the pen is held in the writing position, the nib should point in exactly the same direction as the slant lines.

When the nib is inserted, the point should meet the center line of the pen staff.

Use this illustration as a full-size guide for alignment.

This pen is rather awkward to use, but it's easy to make and it works!

40

An Adjustable Elbow Pen

Cut metal strip from coffee can (or similar), 1/2" x 2".

Double it.

Cut to this shape.

Form with needle-nose pliers.

Drill 1/8" hole.

With small saw, slit pen staff to a depth of 5/8".

Drill 1/8" hole in pen staff, 5/16" from end.

Assemble and fasten with a tiny bolt and nut.

Use a wooden pen staff or even a piece of 3/8" dowel rod. The nib is adjustable to almost any angle.

Let no pleasure tempt thee

no profit allure thee, ———
no ambition corrupt thee, ———
no example sway thee, ———
no persuasion move thee ———
to do anything which thou knowest
to be evil; so shalt thou always live
jollily, for a good conscience is a
continual Christmas.

Benjamin Franklin